THIS BOOK BELONGS TO

Nano

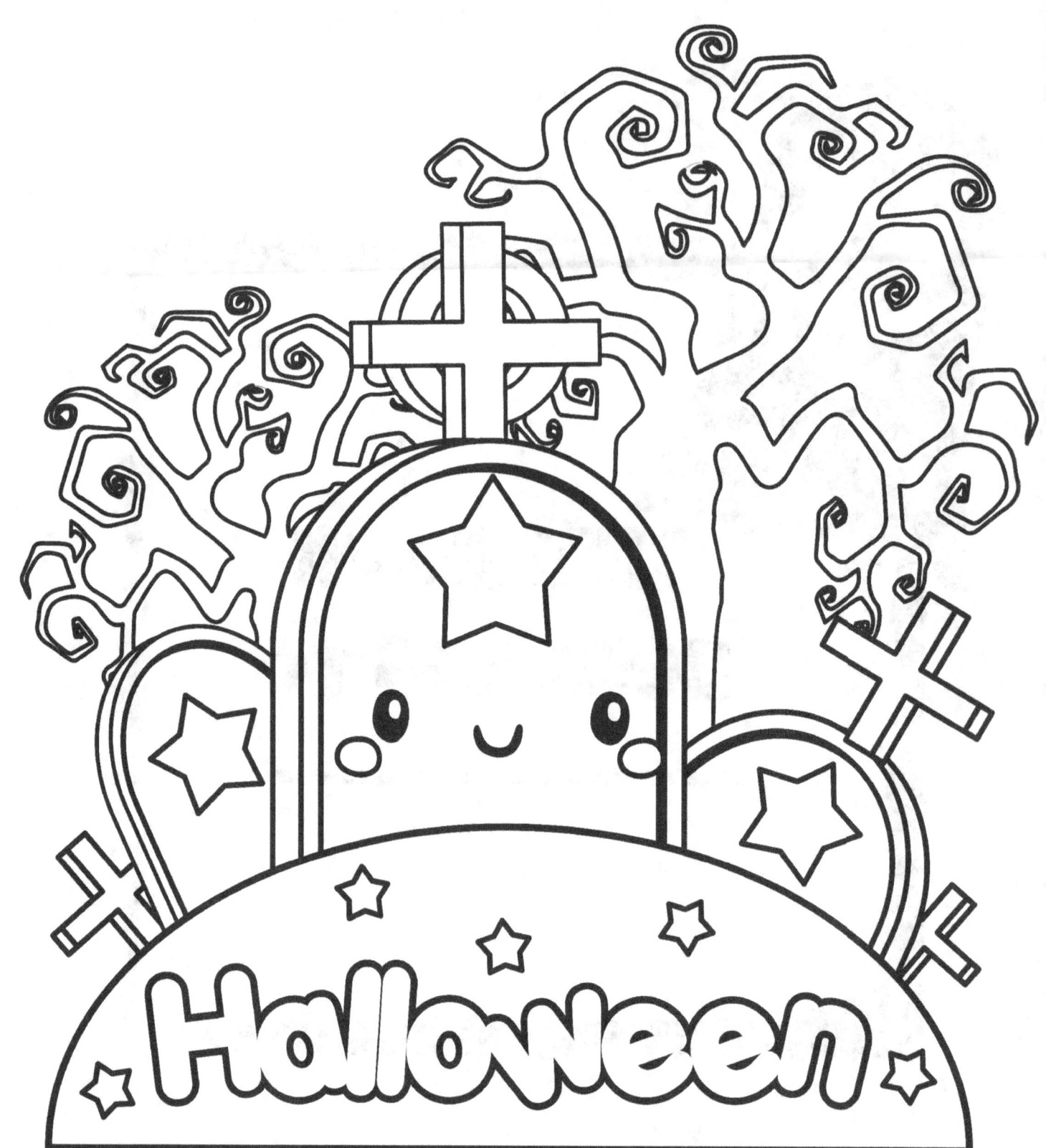

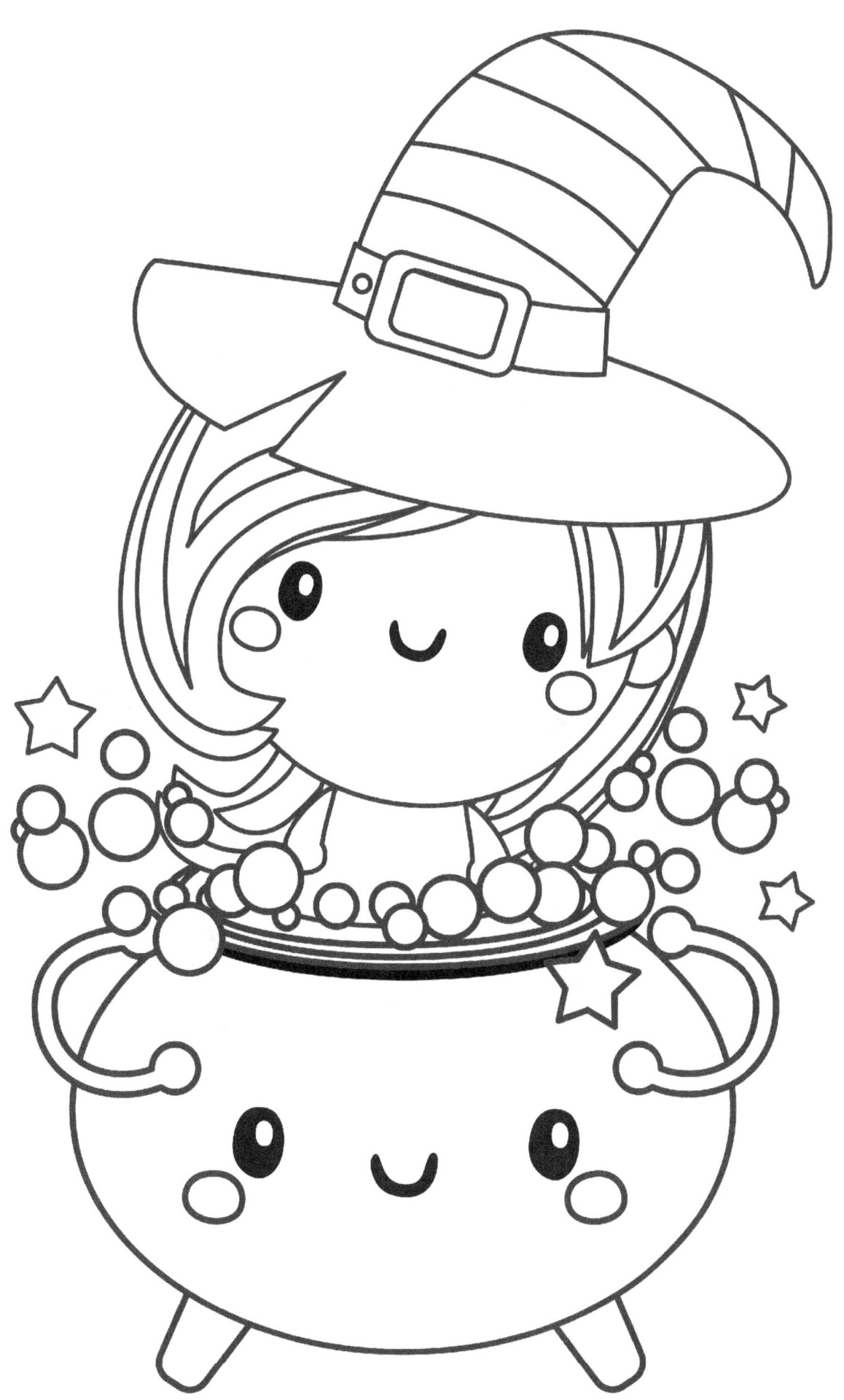

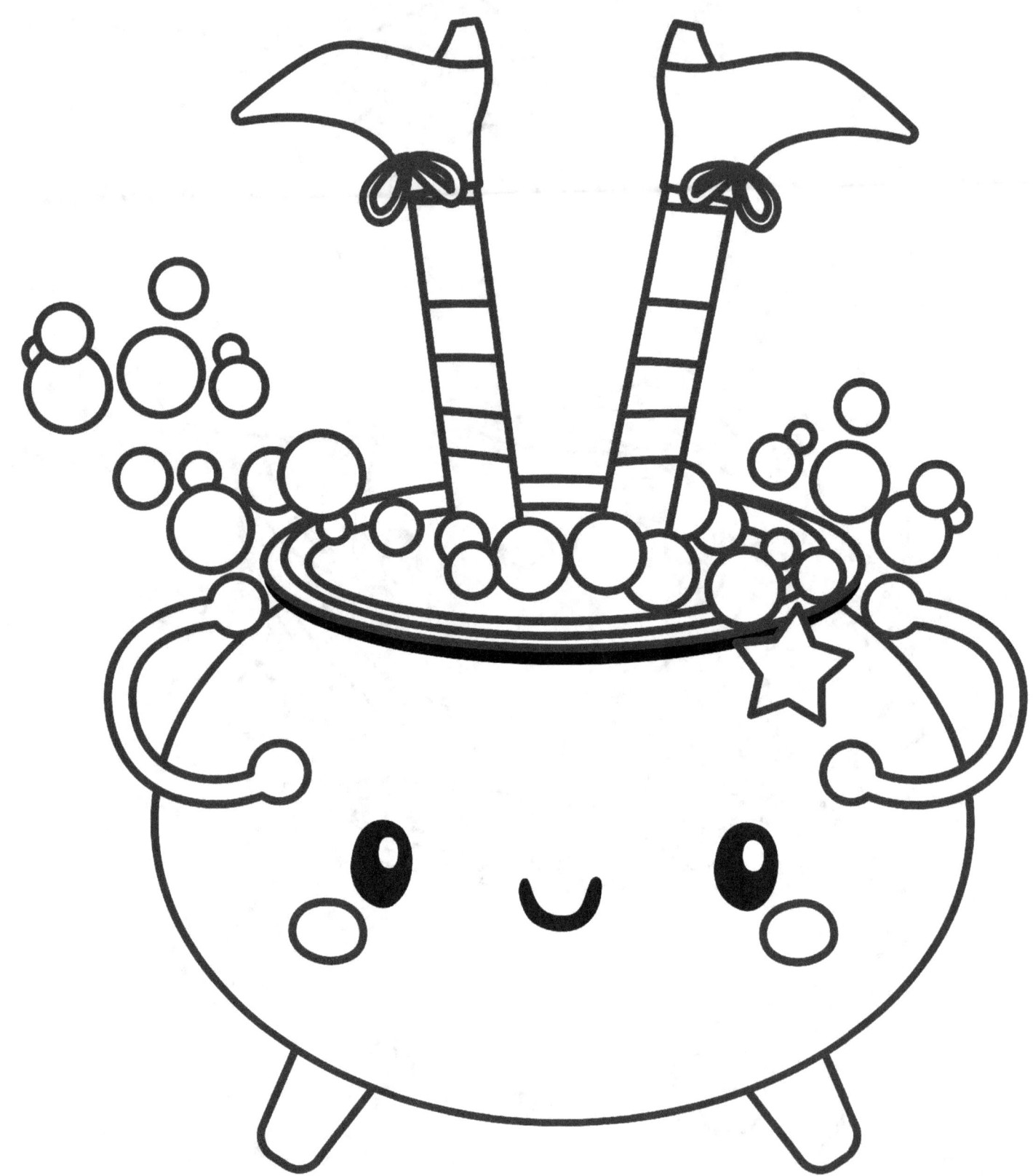

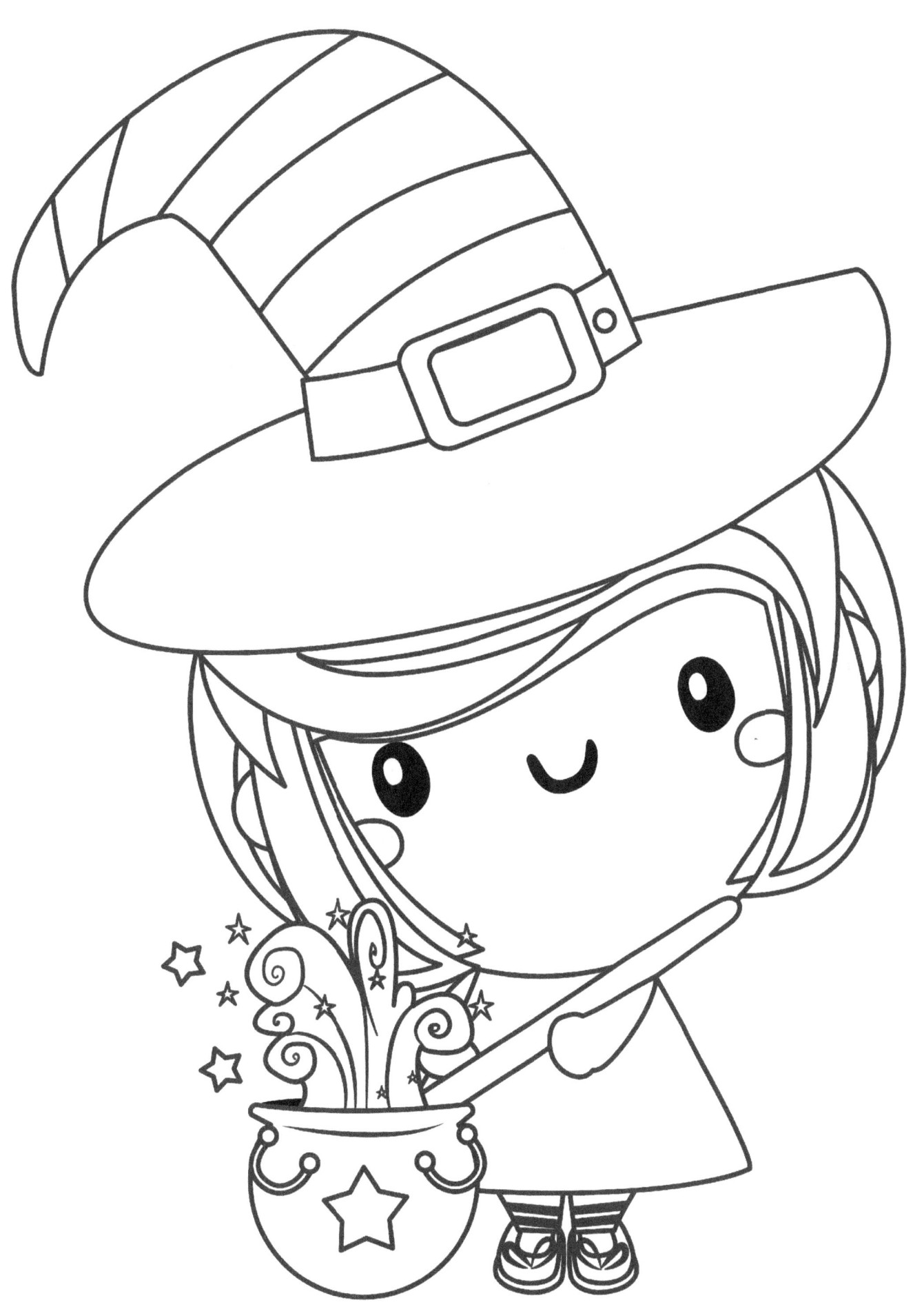

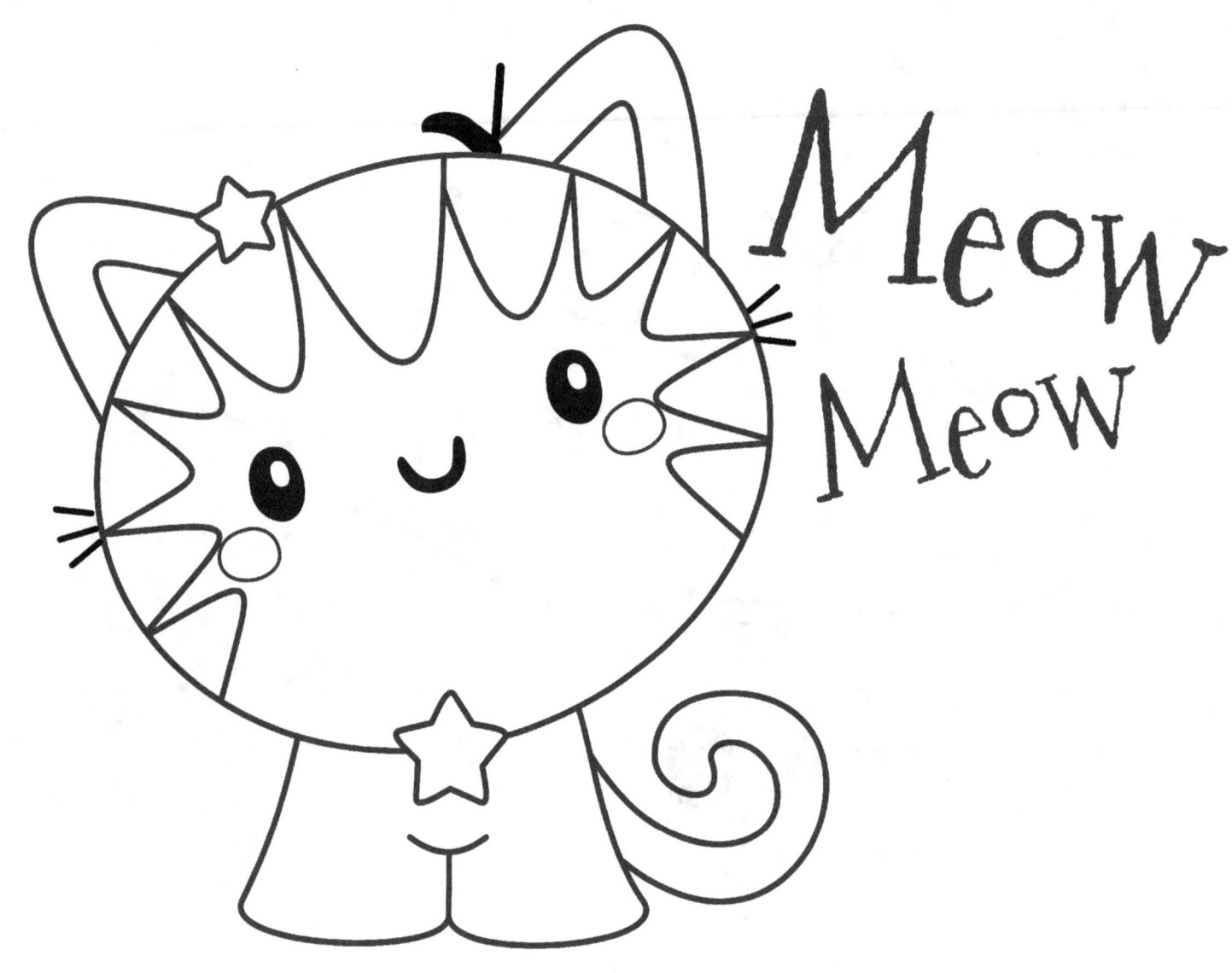

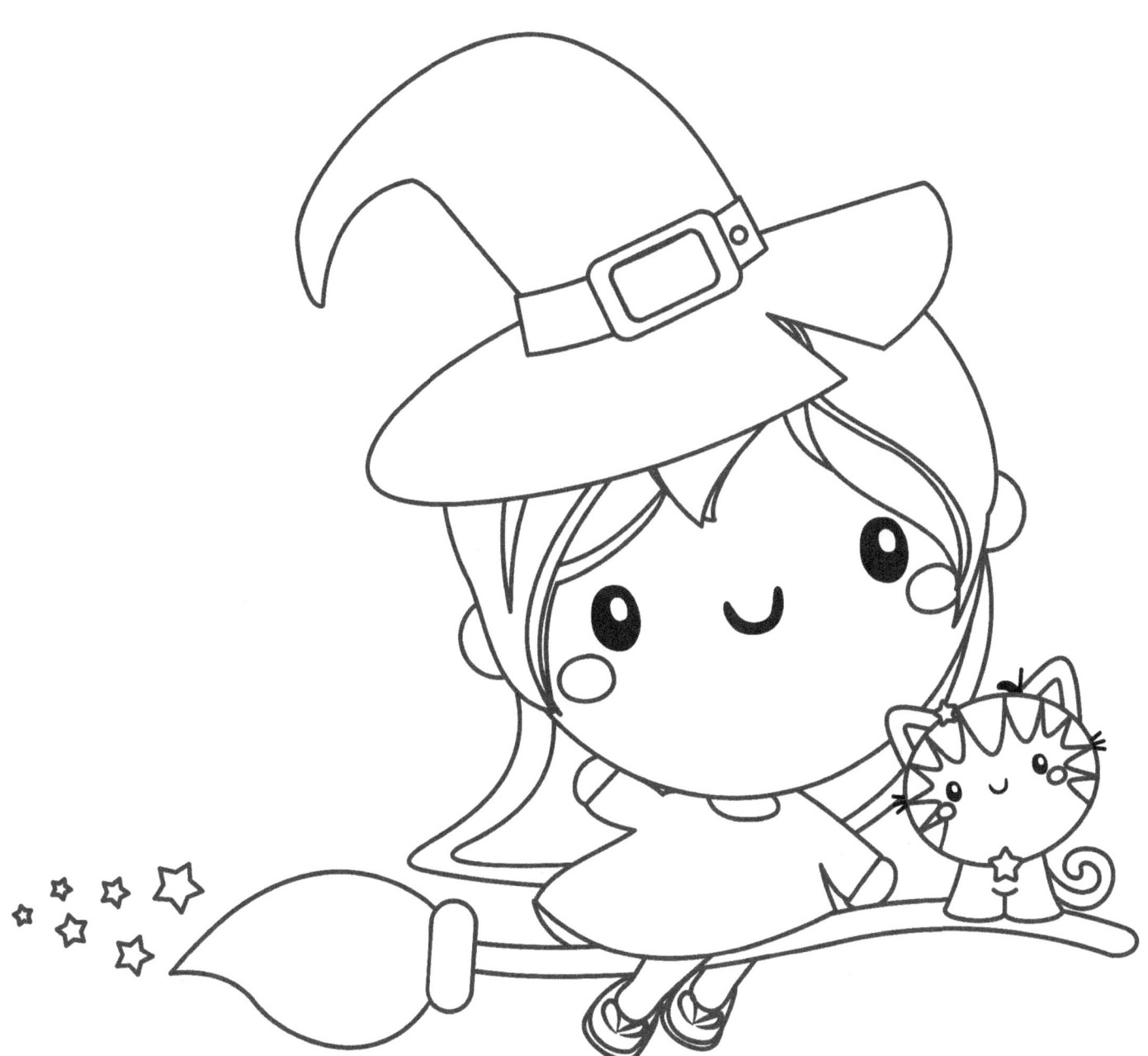

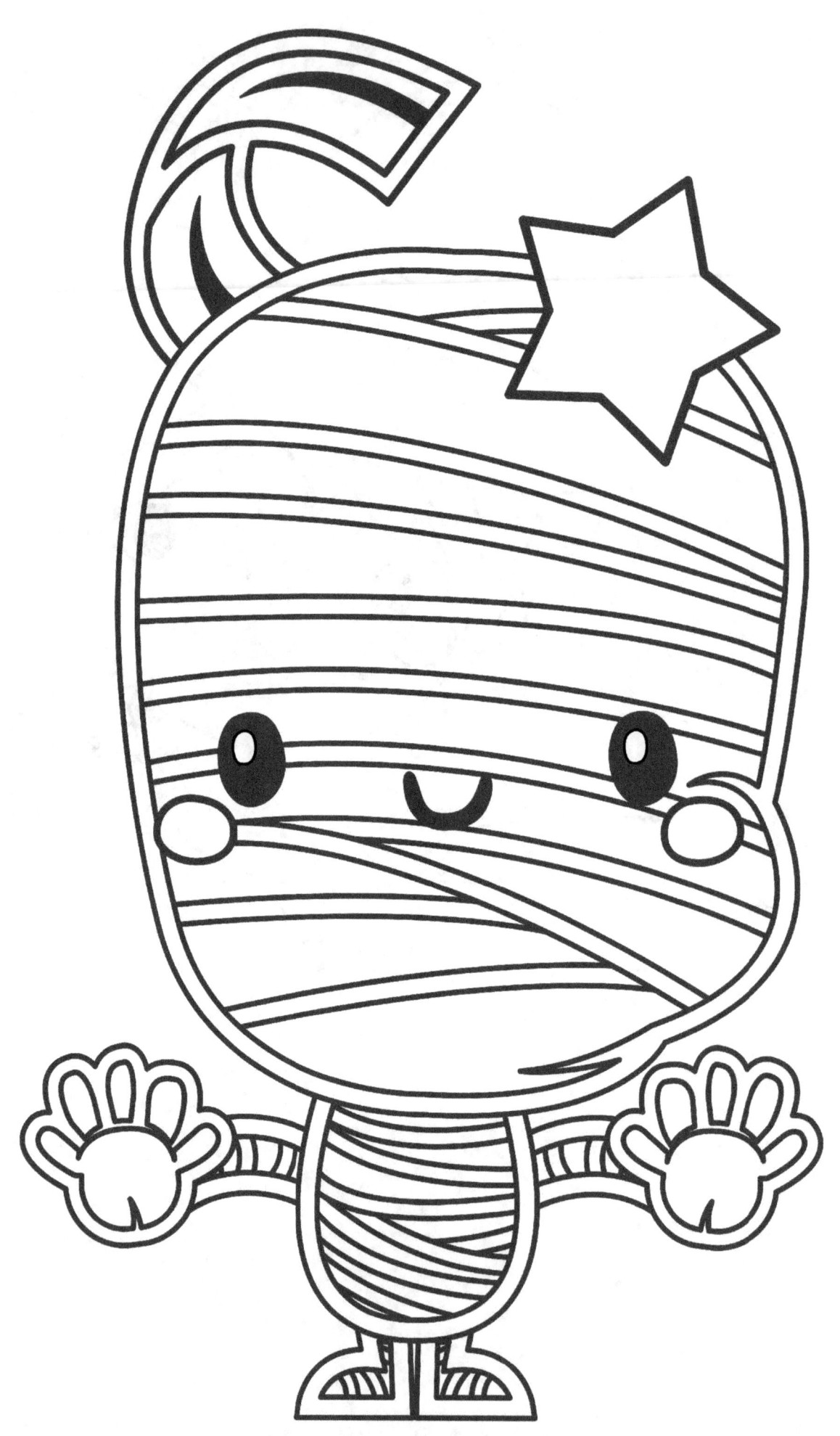

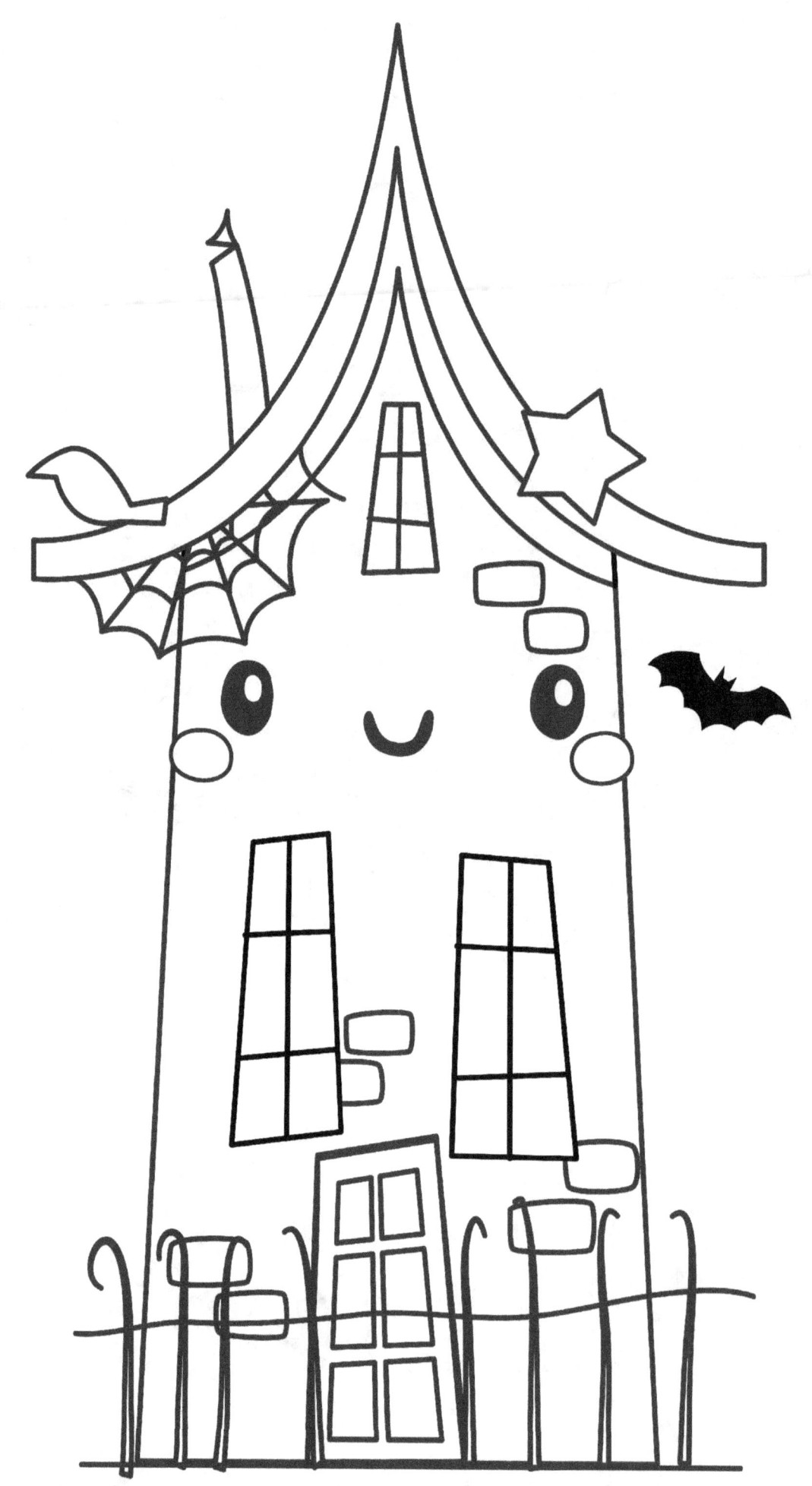

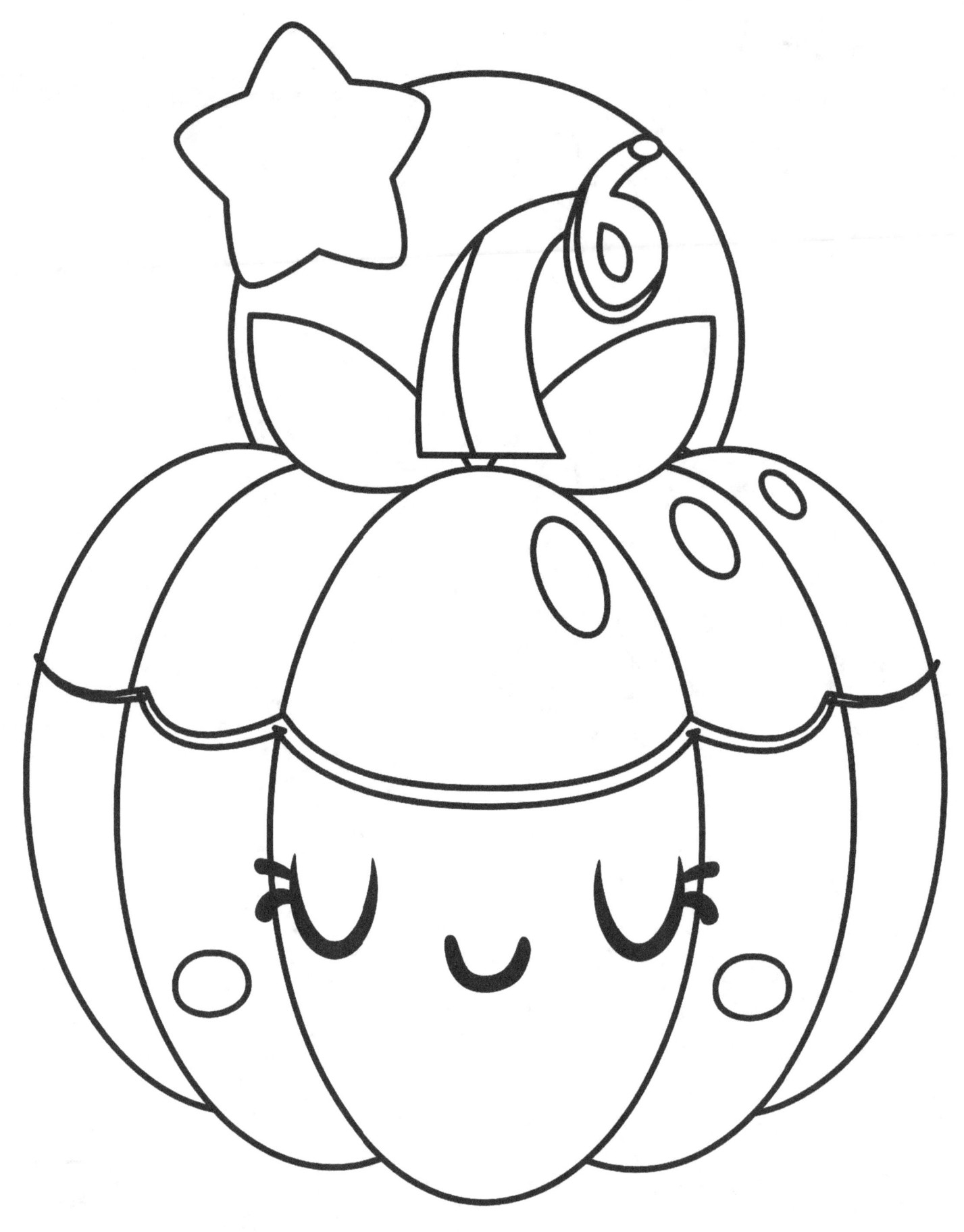

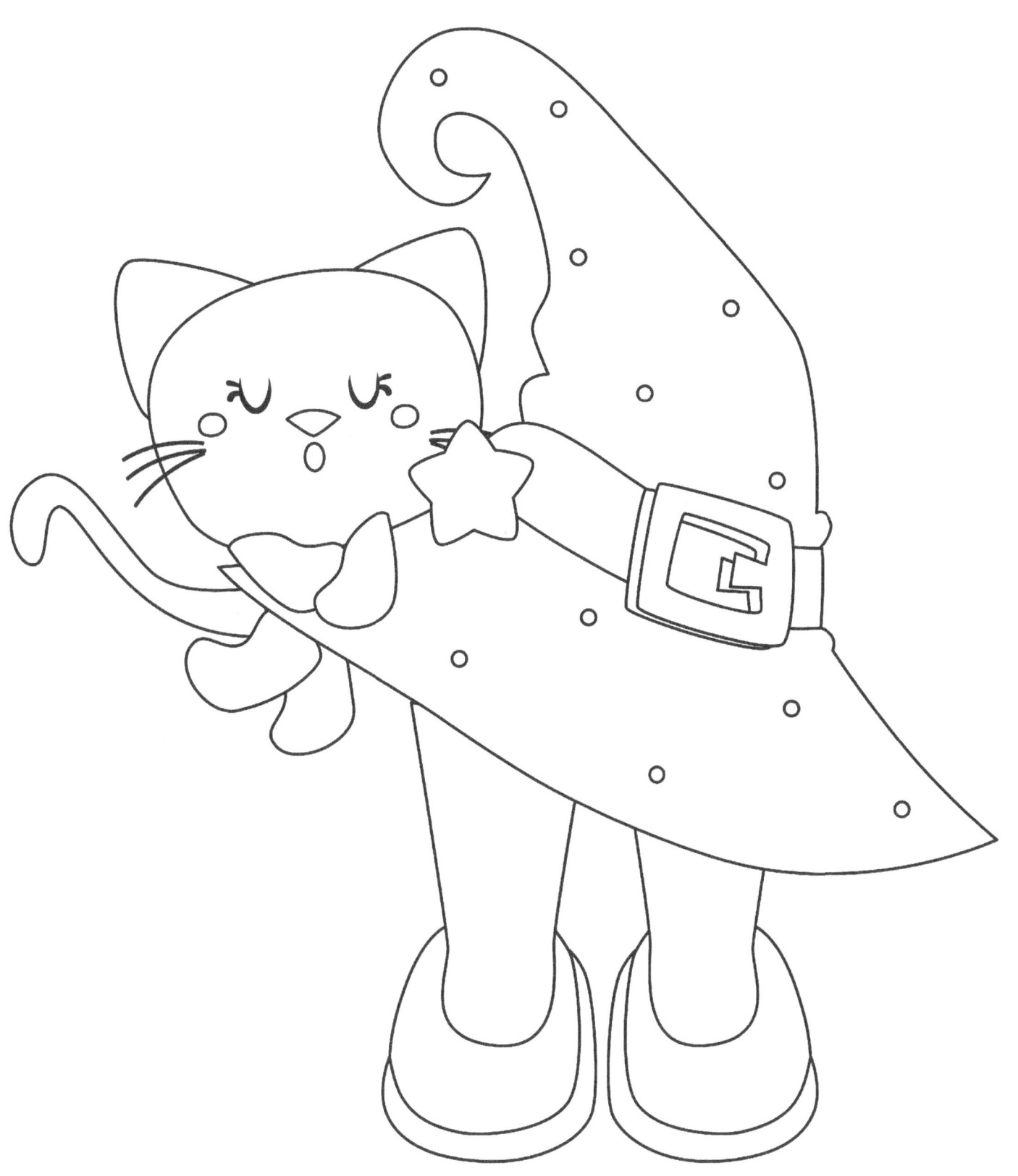

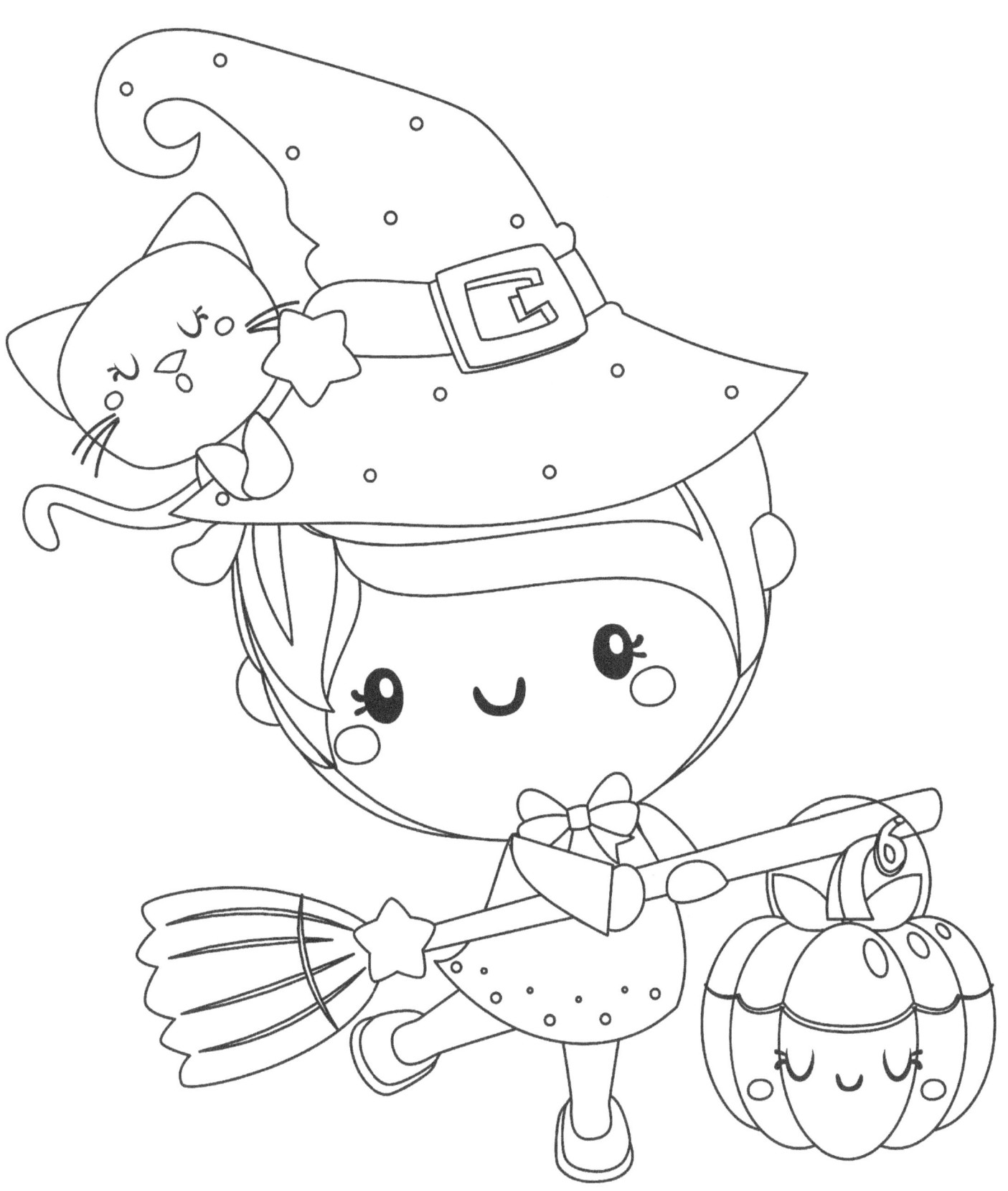

witch hugs

Have a Boo-tiful DAY

www.ingramcontent.com/pod-product-compliance
Lightning Source LLC
Chambersburg PA
CBHW081703220526
45466CB00009B/2860